THE
LINDISFÆRNE
GOSPELS

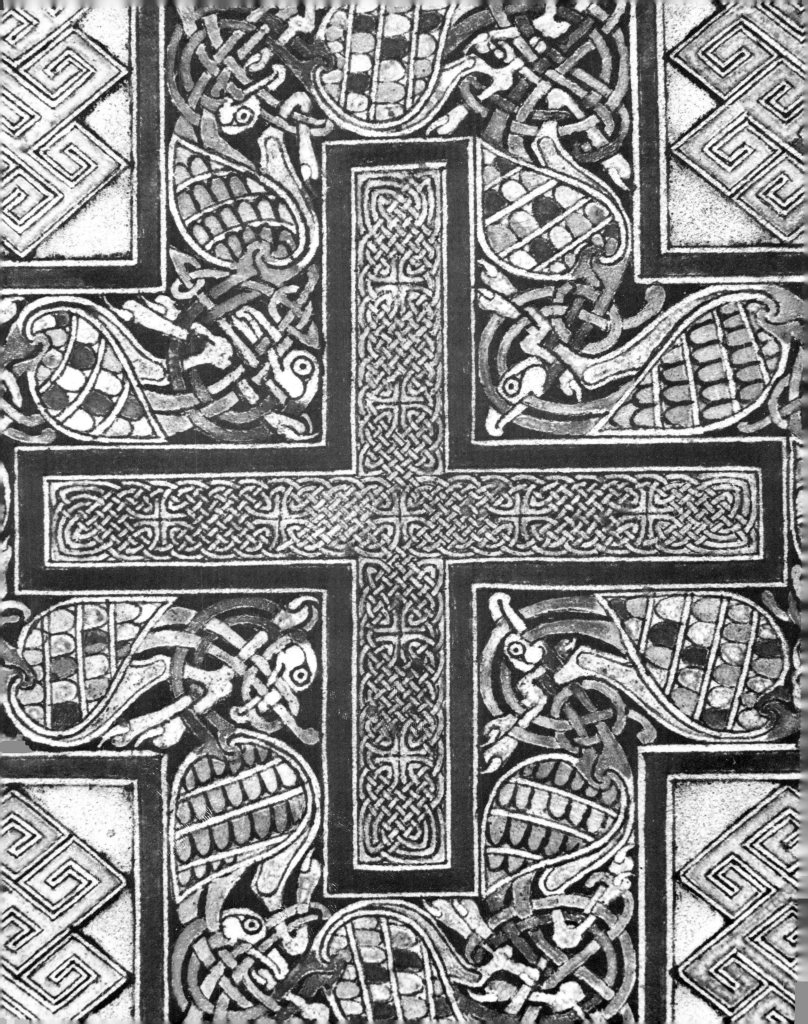

THE
LINDISFARNE
GOSPELS

JANET BACKHOUSE

PHAIDON · OXFORD

To the memory of
Professor Dame Lillian Penson
(1896 – 1963)

Phaidon Press Limited, Littlegate House, St Ebbe's Street, Oxford,
in association with the British Library
First published 1981

This edition published by Marboro Books by arrangement
with Phaidon Press Ltd, 1986

British Library Cataloguing in Publication Data
 Backhouse, Janet
 The Lindisfarne Gospels.
 1. Bible. New Testament. Gospels. *Latin.*
 Lindisfarne. Gospels — Criticism, interpretation, etc.
 I. Title
 226'.04'.7 BS2552.L5
ISBN 0-7148-2148-9

Printed in Singapore by GnP Consultants Pte Ltd

CONTENTS

ACKNOWLEDGEMENTS

The Lindisfarne Gospels is one of the most cherished treasures of the British Library, and many members of the staff of the Manuscripts Department have given help, both practical and academic, during the preparation of this book. I am particularly grateful to the Keeper of Manuscripts, Daniel Waley, for his enthusiastic encouragement of the project. I am also grateful to Bernard Dod and Freda Quartley of the Phaidon Press, who made the practical arrangements run so smoothly, and to Bruce Barker-Benfield, who read through the typescript and helped to clarify a number of points.

Thanks are due to Leslie Webster, Andrew Oddy and Judy Rudoe of the British Museum; Professor Rosemary Cramp of Durham University; Dr George Salt of King's College, Cambridge; Canon A. N. Barnard of Lichfield; Canon R. L. Coppin of Durham; Revd. D. A. Bill of Holy Island and Revd. I. D. Bunting of Chester-le-Street, for information on particular points and for help in obtaining photographs. Sources of photographs are included in the captions; those for which no source is given were supplied by the British Library's photographic service.

Special thanks go to Lawrence Pordes, senior photographer in the British Library, for his skill and patience in making a new set of photographs of the manuscript, many of which are used here; and to Shelley Jones, who has been very much involved with the subject from the beginning, and with whom I visited the manuscript's three medieval homes, Saint Cuthbert's hermitage on Farne Island, and many other sites and monuments in Anglo-Saxon Northumbria.

1. LINDISFARNE AND SAINT CUTHBERT

The Lindisfarne Gospels (British Library, Cotton MS Nero D.iv), made in north-east England less than a century after the introduction there of Christianity and now rapidly approaching its 1,300th birthday, is one of the world's greatest masterpieces of manuscript painting. Fortunately for the many generations of scholars and art lovers who have studied and admired it, it is also one of the best documented. About the middle of the tenth century a priest called Aldred, who had added to it an Anglo-Saxon translation of the Latin text, wrote on the last leaf a colophon naming the four men who made it, including himself. Although the book was already some 250 years old, Aldred was certainly recording well-established tradition, and there is no reason to doubt his statement. In modern English the colophon reads:

> Eadfrith, Bishop of the Lindisfarne Church, originally wrote this book, for God and for Saint Cuthbert and — jointly — for all the saints whose relics are in the Island. And Ethelwald, Bishop of the Lindisfarne islanders, impressed it on the outside and covered it — as he well knew how to do. And Billfrith, the anchorite, forged the ornaments which are on it on the outside and adorned it with gold and with gems and also with gilded-over silver — pure metal. And Aldred, unworthy and most miserable priest, glossed it in English between the lines with the help of God and Saint Cuthbert....

The monastery of Lindisfarne, where Eadfrith and Ethelwald were bishops, was founded in or about AD 635 on a small outcrop of land, now known as Holy Island, lying among the sands about a mile and a half off the Northumberland coast and 12 miles south of Berwick-upon-Tweed (plate 1). The site is marked by the ruins of a later medieval priory, founded about 1083 as a dependency of Durham Cathedral Priory (plate 2). Today about 200 people live on Holy Island, most of them making a living either from fishing or through some aspect of the tourist trade, which every year brings thousands of visitors to their village. The modern causeway has a metalled surface, but until very recently residents and visitors alike were still obliged to follow a track across the sands, exactly as medieval pilgrims had done. Twice each day, for several hours at a time, the island is cut off from the mainland by the sea, which means that everyday matters such as postal deliveries and bus timetables are governed by the movements of the tide. To the members of the seventh-century monastic community the situation must have seemed ideal, the sea providing a visible barrier between them and the world (and at least a partial defence against attack from the land), without entirely hindering them in their comings and goings as missionaries and preachers in other parts of the kingdom of Northumbria.

The first Christian mission to the Anglo-Saxon population of Northumbria was undertaken by Saint Paulinus, one of a group of

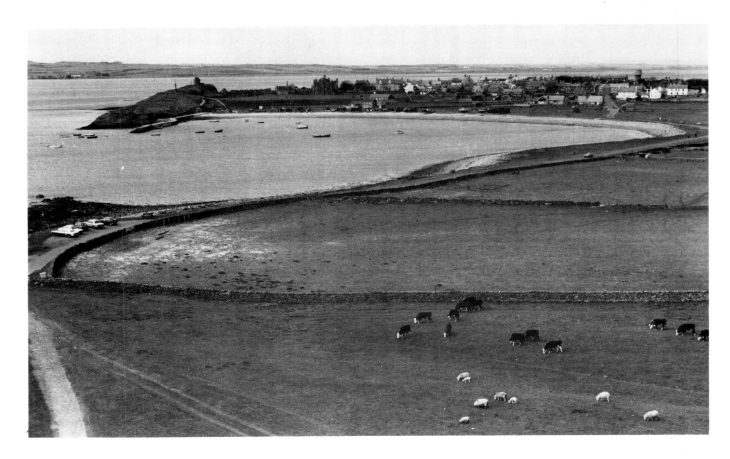

1. Present-day view of the village and harbour of Holy Island. The ruins of Lindisfarne Priory stand between the houses and the promontory and harbour wall (*photo: the author*).

men sent from Rome to England in 601 by Pope Gregory the Great to assist in the work of conversion already begun in Kent by Saint Augustine. Paulinus came north in 625 as chaplain to the Christian Princess Ethelberga of Kent, bride of King Edwin of Northumbria, and his preaching, supported by the conversion of the king, met with great success. However, Edwin's death in battle in 633 resulted in a resurgence of paganism, and Paulinus and Ethelberga fled back to the south. Two years later King Oswald, eager to re-establish the new faith, sent to the Irish monastery on Iona for priests. A fresh mission was led by Saint Aidan, and it was he who founded the monastery on Holy Island, conveniently close to his royal patron's stronghold on the rock of Bamburgh, which is clearly visible from Lindisfarne. Saint Aidan and his companions travelled the length and breadth of Northumbria, usually on foot, preaching and baptizing. By the time of Aidan's death in 651 the Christian faith was firmly established in the area and several further monastic communities had been founded.

Saint Cuthbert, in whose honour the Lindisfarne Gospels was to be made, was born about the time of the arrival of the missionaries from Iona. We know a great deal about him because, only a few years after his death, two detailed accounts of his life were written. The first was by an anonymous monk of the Lindisfarne community and the second, in part based upon it, was by the Venerable Bede, the 'father of English history', who died in 735. Both men were able to include material gathered from people still living who had known Saint Cuthbert well. He seems to have been a warm-hearted and practical person, and many of his miracles involve delightful animal stories.

Cuthbert entered the monastery of Melrose, in what is now lowland Scotland, soon after Saint Aidan's death, which he had seen in a vision while caring for sheep in the Lammermuir Hills. After a period of study under Boisil, the saintly prior of Melrose, he was ordained priest

8

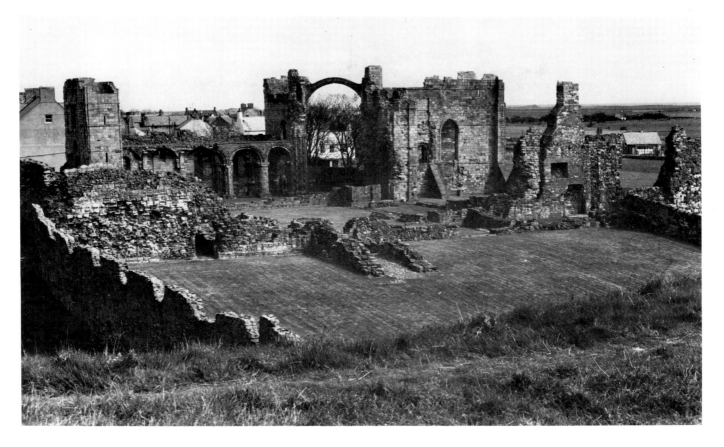

2. The ruins of Lindisfarne Priory, built probably on the site of the Anglo-Saxon monastery. The Priory was founded about 1083 as a dependency of Durham Cathedral Priory, and the massive decorated columns of the ruined church are very similar to those in Durham Cathedral itself (*photo: the author*).

and began to journey about Northumbria, preaching and administering the sacraments, and rapidly acquiring a reputation for holiness and for the possession of miraculous powers. He spent a short period at Ripon, where he helped to found a new monastery, succeeded Boisil as prior of Melrose, and was eventually sent to Lindisfarne to reform the way of life of the community, as discipline there had become slack. At Lindisfarne Cuthbert found himself more and more attracted to the idea of a life of solitude. He began by withdrawing occasionally to a tiny islet only a few yards off the shore of the main island and, like it, accessible on foot at low tide. Later he moved to Farne Island, directly opposite Bamburgh, where he built himself a hermitage from which he could see nothing but the sky. There he lived alone for a number of years, visited not only by the monks of his own community but also by many people from far and near who had been attracted by his growing reputation for saintliness. In 684, after King Ecgfrith himself had visited the island to plead with him, Cuthbert bowed to pressure to accept election as a bishop, and the following Easter he was consecrated at York by Archbishop Theodore of Canterbury.

For the short space of two years Saint Cuthbert returned to his earlier itinerant life. Then, feeling that the end of his life was approaching, he returned to his hermitage on Farne Island. One of his last miracles, used by Bede to demonstrate the virtue of obedience, kept a group of monks from Lindisfarne imprisoned on the island by a storm for an entire week because they had neglected to obey his instructions to cook and eat a goose hanging ready in his little guest house (plate 3). He died on 20 March 687, attended at the last by a small group of his brethren, and his passing was signalled across the sea to Holy Island by the waving of torches.

Cuthbert himself realized that he would be venerated as a saint and that his tomb would quickly attract pilgrims. He would have preferred

a simple grave on Farne Island, where he had a sarcophagus and a winding sheet in readiness, but he yielded to the wishes of the community and agreed that his body might be taken to Lindisfarne for burial. It was usual for the remains of a holy man to be left in the earth long enough for the soft parts of the body to disintegrate, and then for the bones to be raised, washed, wrapped in fine cloths, and placed in a casket above ground where they could be visited by the faithful. This 'elevation' of the relics amounted to a formal declaration of sainthood. Eleven years elapsed before Cuthbert's successor, Eadbert, gave his consent for the grave to be reopened. In the meantime a new roof of lead was placed on the monastery's wooden church, a carved oak chest was made to receive the relics, and, almost certainly also during this period, the Lindisfarne Gospels itself was written and illuminated. At last, in 698, on the anniversary of Cuthbert's death, the grave was opened to reveal a body miraculously undecayed, in further proof of holiness (plate 4). It was reverently placed in its casket and laid on the floor of the sanctuary. As Cuthbert had foreseen, pilgrims flocked to the shrine and miracles were soon recorded.

In 793, apparently without warning, Lindisfarne was raided and sacked by Vikings. Writing from the court of Charlemagne to King Ethelred of Northumbria, Alcuin of York exclaimed: '… never before has such terror appeared in Britain as we have now suffered from a pagan race, nor was it thought that such an inroad from the sea could be made.' Although the community soon returned to the island, it was

3. The miracle of the uncooked goose. An illustration from a copy of Bede's prose Life of Saint Cuthbert, written and decorated at Durham Cathedral Priory about 1100–20. University College, Oxford, MS 165, p. 98 (*Bodleian Library, Oxford*).

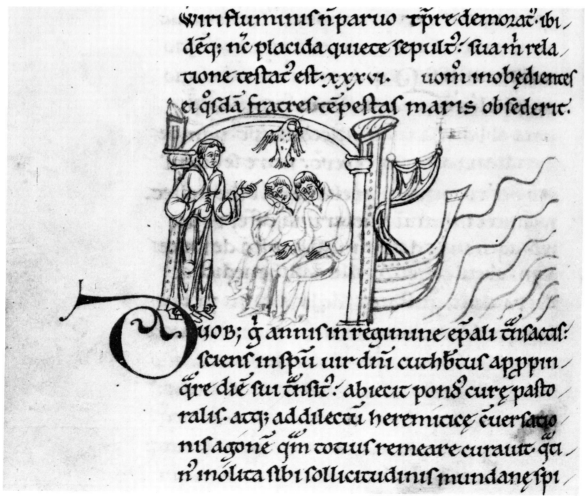

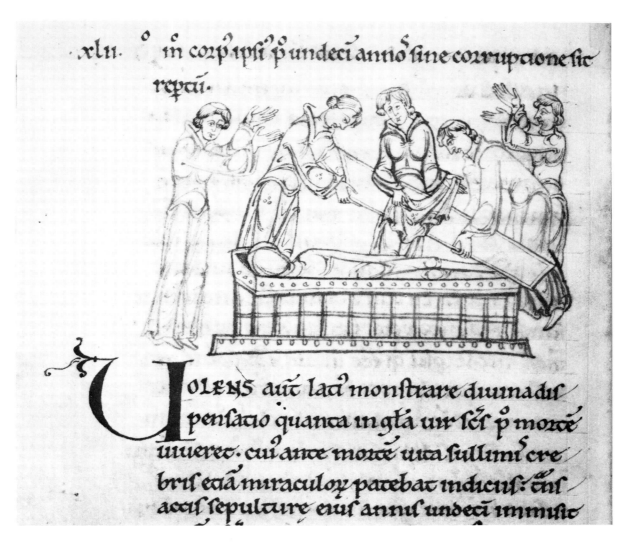

xlii. ^o in corp ipsi p undeci annos sine corrupcione sic repti.

VOLENS aut lat^a monstrare diuina disp^{ensatio} quanta in gl^a uir scs p morte uiueret. cui ante morte uita sublimi crebris etia miraculoz patebat indiciis: tunc acctis sepulture eius annis undeci immisit

4. The opening of Saint Cuthbert's grave in 698. The monks display their astonishment at finding his body miraculously undecayed. University College, Oxford, MS 165, p. 118 (*Bodleian Library, Oxford*).

with an increasing sense of unease as monastery after monastery suffered the same fate. At last, in 875, Bishop Eardulf took the relics of Saint Cuthbert and other treasures of the monastery, including the Lindisfarne Gospels and the bones of the two men who had made it, his predecessors Eadfrith and Ethelwald, and set off in search of a safer home. He was accompanied by all the inhabitants of the island, seven of whom were given special charge over the relics. Their wanderings, chronicled at the beginning of the twelfth century by Symeon of Durham, lasted about seven years. There was a time when it seemed that their final destination would be Ireland, but we are told that, as the bishop and his party tried to put out to sea, a terrible storm arose, three great waves swept over the ship and were turned to blood, and a copy of the Four Gospels, richly bound in gold and jewels, was swept overboard and lost. This was taken as a sign of the saint's displeasure, and the voyage was immediately abandoned. Saint Cuthbert then appeared in a dream to Hunred, one of the seven bearers, and told him where the manuscript could be found, washed up unharmed on the sands at a low tide. According to Symeon of Durham, the manuscript was the Lindisfarne Gospels.

Not long after this episode, the party settled at Chester-le-Street, in County Durham, where Saint Cuthbert's relics remained until 995, and it was there that Aldred the priest added his Anglo-Saxon gloss and colophon to the manuscript, probably during the third quarter of the tenth century.

2. THE MEN WHO MADE THE MANUSCRIPT

Four men are named in Aldred's colophon (plate 5) as contributors to the making of the Lindisfarne Gospels. The first is Bishop Eadfrith of Lindisfarne, who succeeded Bishop Eadbert in 698, shortly after Saint Cuthbert's elevation. He is said to have written the manuscript. The second, credited with binding it, is Bishop Ethelwald of Lindisfarne, who succeeded Eadfrith in 721. The third is Billfrith the Anchorite, who provided ornaments of gold, silver and jewels for its outer casing. The fourth is Aldred himself, who inserted the Anglo-Saxon translation or gloss.

Nothing is known of Eadfrith before he became bishop of Lindisfarne in May 698, except that he was apparently a member of the Lindisfarne monastic community. There are, however, several references to his activities after that date. Both the anonymous Life of Saint Cuthbert by one of the monks of Lindisfarne and the prose Life by the Venerable Bede are addressed to him. Eadfrith honoured Bede in return by promising that his name should be inscribed in the Lindisfarne *Liber Vitae* or *Book of Life* by Guthfrith the sacrist, and that he should be remembered in the prayers of the community. The original *Liber Vitae* kept by Guthfrith is no longer in existence, but a magnificent copy in letters of gold and silver was made about the middle of the ninth century. This is now in the British Library (Cotton MS Domitian A.vii) and Bede's name indeed appears in it, on folio 18b. In the prose Life, Bede refers to the restoration of Saint Cuthbert's hermitage on Farne Island by Eadfrith for Felgild, the saint's second successor there. From another eighth-century work, a Latin poem known as the *De Abbatibus*, by a monk called Ethelwulf, we learn that Eadfrith also gave advice and assistance in the foundation of Ethelwulf's own monastery, the history of which the poem recounts but the name of which unfortunately we do not know.

Ethelwald makes several appearances in Bede's *Ecclesiastical History* as well as in the Lives of Saint Cuthbert. As a young novice, he had been in personal attendance upon the saint, and he was witness to one of Cuthbert's miracles, when one of his own kinswomen was cured of an intolerable pain affecting her head and one side of her body. Soon after the elevation of the saint's relics in 698 he moved from Lindisfarne to Melrose, where he remained, first as prior and then as abbot, until shortly before he succeeded Eadfrith as bishop in 721. He died in or about 740 and was buried on Lindisfarne at the foot of a large stone cross which he himself had erected. This was later to be removed to Durham.

Of Billfrith's life nothing at all is known, except that he was an anchorite, or hermit, as Saint Cuthbert himself had been. He was also a priest. His name appears at the head of the second column on the page devoted to anchorites in the Lindisfarne *Liber Vitae* (folio 15), and its position in relation to other known names suggests that he probably

died during the latter part of the eighth century. The high regard in which anchorites were held is reflected in the fact that only two classes of people, both largely of royal blood, are placed before them in the *Liber Vitae*.

The wording of Aldred's colophon is not entirely unambiguous and there has been much discussion about its exact meaning. Some scholars have argued that Eadfrith and Ethelwald did not themselves make the manuscript but merely commissioned someone else to do so. However, Symeon of Durham, writing in the early twelfth century but with the full weight of local tradition behind him, says quite categorically that Eadfrith wrote the book with his own hand.

5. The Anglo-Saxon colophon added to the manuscript by Aldred in the mid-tenth century. It names Eadfrith, Ethelwald, Billfrith and Aldred himself as the four contributors to the making of the manuscript. A translation is given on p. 7 above. The Lindisfarne Gospels, folio 259 (detail).

The careful examination of the manuscript made when the facsimile edition was published 25 years ago showed clearly that, with the exception of the rubrics and some contemporary corrections and additions to the text, the whole of the Gospels had been written out by a single scribe. Furthermore, the decoration is so closely linked to the writing, particularly in one or two places where the original scheme was sketched out and then changed before the page was finished, that it must have been the work of the scribe himself. The examination also suggested that the book had been designed and made in a single campaign, without major interruption, and that it probably took at the very least two years to complete. This may be a considerable underestimate, as we do not have details about matters such as the weather. In 764 the Abbot of Wearmouth–Jarrow wrote to a friend, blaming an exceptionally cold winter for his scribe's inability to complete some books.

It seems unlikely that Eadfrith would have had the leisure to undertake a major artistic task of this kind after his election as bishop, when his life no doubt took on the strenuous pattern of travelling and preaching familiar from that of Saint Cuthbert. It is much more likely that he made the Gospels in the period immediately before the elevation of the relics in 698, when he was still only a senior member of the community, possibly head of the monastic scriptorium. Talented scribes and illuminators were held in very high esteem. Saint Columba, founder of Iona, was particularly noted for his activities as a scribe, and the *De Abbatibus* includes an account of an Irish monk called Ultan whose hand, 'once used to write the Lord's word', performed a miraculous cure as his bones were being raised from their original resting place. A senior monk who was also a talented scribe might well have been seen by his brethren as the most suitable candidate for election as bishop.

The known facts of Ethelwald's career also point to a date before 698 for the making of the Gospels. Immediately before the elevation he too was apparently only a senior member of the Lindisfarne community, but sometime between 699 and 705 he moved from the island to Melrose, not returning to Lindisfarne until 721. It thus seems sensible to suppose that he bound the manuscript before his departure, but the binding has long since disappeared. One single leather book binding made in Northumbria at this date has survived, the earliest European binding still associated with the manuscript for which it was made. This is the binding of the Saint Cuthbert Gospel, an exquisite little copy of the Gospel of Saint John which was found in Saint Cuthbert's coffin when his relics were translated to their new resting place in Durham Cathedral in 1104. The Gospel, which is at present on loan to the British Library, was copied in Bede's community of Wearmouth–Jarrow and may perhaps have been a gift to Lindisfarne in honour of the elevation. The binding is of crimson goatskin over beechwood boards, and the raised decoration on the front cover is moulded over cords (plate 6).

The exact form of Billfrith's contribution will never be known, for with Ethelwald's it disappeared centuries ago, probably at the Reformation. It was not uncommon for precious decoration to be added to the bindings of special Gospel books. Symeon of Durham's account of the Lindisfarne Gospels suggests that Billfrith's work was carried out at the request of Ethelwald whilst he was Bishop (721-40). No English jewelled binding of so early a date survives, but the silver plates added to Saint Cuthbert's portable altar presumably date from 698 and are therefore contemporary (plate 7).

6. The contemporary binding of the late seventh-century Saint Cuthbert Gospel (also known as the Stonyhurst Gospel), found in the coffin of Saint Cuthbert at the time of his translation in 1104, and at present on loan to the British Library (*by permission of the English Province of the Society of Jesus*).

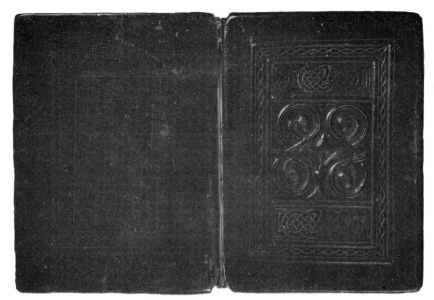

7. Fragments of silver ornaments from the back of Saint Cuthbert's portable altar. The fragments bearing foliate ornament probably date from the time of the elevation of the relics in 698. The decorated central patch is a ninth-century repair. The altar was found lying on Saint Cuthbert's breast when his tomb was opened in 1827 (*Durham Cathedral Library*).

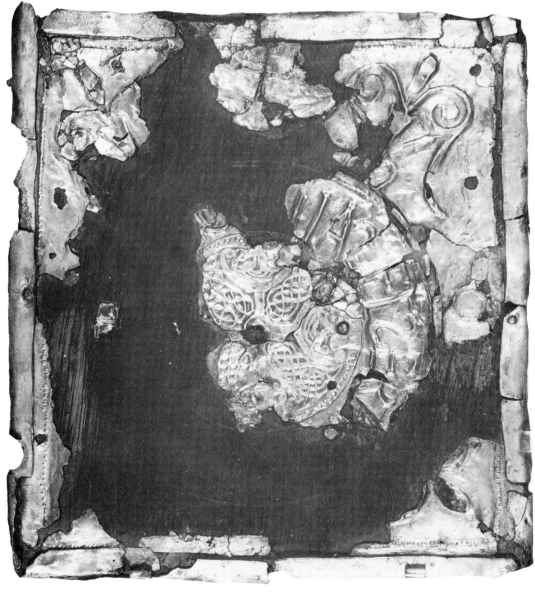

Personal information about Aldred himself is also scanty. His father, according to a marginal note beside the colophon, was called Alfred. Two other manuscripts have additions which have been recognized as by his hand. One is the oldest surviving copy of Bede's Commentary on the Book of Proverbs (Bodleian Library, Oxford, MS Bodley 819; plate 12), written in the Wearmouth–Jarrow scriptorium in the second half of the eighth century and known to have been at Durham in the twelfth. The other, which reveals that Aldred advanced to be provost of Chester-le-Street, is the so-called Durham Ritual (MS A.IV.19 in Durham Cathedral Library), a collection of liturgical material probably written out in the south of England in the early tenth century, to which Aldred added (on page 167) four collects in honour of Saint Cuthbert. The collects are accompanied by a note recording that they were written out for Bishop Aelfsige by Aldred the Provost, at a place called Oakley, on a feast of Saint Lawrence which was also the fifth night of the moon. Aelfsige was bishop of Chester-le-Street between 968 and 990, and the feast of Saint Lawrence (10 August) coincided with the fifth night of the moon in 970. Oakley appears to be identifiable as a place in Wessex, on the road between Salisbury and Blandford. It seems likely that Aelfsige, accompanied by Aldred, was in attendance upon King Edgar at the appropriate time.

In the Lindisfarne Gospels colophon, which must be earlier than the note in the Durham Ritual because in it Aldred describes himself only as a priest, he goes on to tell us that each Gospel was glossed with a separate special intention. Matthew was for God and Saint Cuthbert, Mark for the bishop, Luke for the community (with the addition of eight 'ores' of silver for his induction), and John for the sake of his own soul (with four 'ores' of silver for God and Saint Cuthbert). This suggests that his work on the manuscript was intended to establish him in the community at Chester-le-Street. It probably dates from shortly after the middle of the tenth century.

3. THE TEXT OF THE GOSPELS

OVERLEAF:
8. A page from Saint Matthew's Gospel, including the beginning of the Sermon on the Mount (Matthew 4: 24–5: 10). Aldred's tenth-century gloss, a word for word translation of the Latin, is added between the lines and in the right-hand margin. The Lindisfarne Gospels, folio 34.

9. A page from the table of feast days preceding Saint John's Gospel. Aldred added little to this page, so the full beauty of Eadfrith's script can be appreciated without distraction. The headings are in a different hand, that of the rubricator. The Lindisfarne Gospels, folio 208.

The Lindisfarne Gospels contains not one but two versions of the Gospel texts. The first is the Latin copied out by Eadfrith and the second the Anglo-Saxon interlinear gloss added two and a half centuries later by Aldred. Aldred's gloss is of great interest to students of English because it represents the earliest surviving translation of the Four Gospels into any form of the English language. It is a literal translation, written word by word between the lines of the Latin text, with occasional passages in the margins (plate 8). There is no necessity to assume that Aldred himself composed it. His colophon quite probably implies that he copied it from some other source which has not come down to us. There is indeed a very similar gloss in the MacRegol Gospels, an early ninth-century Irish manuscript now in Oxford (Bodleian Library, MS Auct. D.2.19), and it is probably not much later in date than Aldred's work. A surprising quantity of Anglo-Saxon literature — original poetry and prose as well as translations of Latin texts — has survived in manuscript. Although a great deal more has doubtless disappeared, England can still boast the richest vernacular literature in Europe from so early a date. It is only necessary to recall that something as celebrated as the *Beowulf* poem is known only from a single copy (British Library, Cotton MS Vitellius A.xv), itself badly damaged as recently as 1731, when it was one of the casualties of the fire which destroyed a considerable portion of the Cotton library, to realize just how vulnerable such material can be.

We know of at least one eighth-century translation of the Gospel of Saint John, though it apparently has not survived. The Venerable Bede was working on it at the time of his death in May 735, and its final sentence was the last thing which he dictated to Wilberht, his young amanuensis.

The Latin Gospel text is that of Saint Jerome's Vulgate, a revision of the Latin Bible made in the late fourth century and subsequently the most widely adopted throughout the western world. In the Lindisfarne Gospels it is preceded by the text of Saint Jerome's letter to Pope Damasus, at whose command the revision had been carried out, by the prologue to Saint Jerome's commentary on Matthew, and by a series of Eusebian canon tables (see below, p. 41), prefaced by the explanatory letter of Eusebius to Carpianus. At the beginning of each of the Gospels is a short introduction ('argumentum'), a list of passages used as liturgical readings ('capitula lectionum') and a list of festivals on which passages from that particular Gospel should be read (plate 9). The last item has no practical value, as details of the passages concerned are not included in it. It is, however, of special interest, as references to Saint Januarius in the lists preceding Matthew and John, and to the dedication of a basilica of Saint Stephen before Matthew, reflect a connection with Naples, suggesting that Eadfrith's exemplar was a Gospel book imported into England from the south of Italy.

abiit opinio eius

in totam syriam

et obtulerunt ei omnes

male habentes

variis languoribus

et tormentis

comprehensos

et qui daemonia

habebant et lunaticos

cos et paralyticos

et curauit eos

et secutae sunt eum

turbae multae

de galilaea et decapo

lim et hierosolimis

et iudaea et de

trans iordanen

uidens autem turbas

ascendit in montem

et cum sedisset accesse

runt ad eum

discipuli eius

et aperiens os suum

docebat eos dicens

beati pauperes spū

quoniam ipsorum est

regnum caelorum

beati mites quoniam

ipsi possidebunt

terram

beati qui lugunt

quoniam ipsi

consolabuntur

beati qui esuriunt

et sitiunt iustitiam

quoniam ipsi

saturabuntur

beati misericordes

quoniam ipsi

misericordiam

consequentur

beati mundo corde

quoniam ipsi dm

uidebunt

beati pacifici

quoniam ipsi filii

di uocabuntur

beati qui persecutio

nem

xinda *bebeadando*

tertio commendans
mid hræcing *honda*

extensione manuum
zahet t *him þæt noder*

significat ei quod crucis
donde venezoyband mid drounge

morte foret martyrio
sez ysferenad

coronandus

quae lectio cum in natale

sancti petri legitur.

a loco incoatur

quo ait

Dicit simoni
petro ihs simon

iohannis

diligis me plus his

usque ad locum ubi dicit

significans qua morte

clarificaturus esset dominum

cum vero in natale sancti

iohannis evangelistae in

choandela est a loco quo

ait dicat ei hoc est dominus

simoni petro sequere me

usque ubi dicit et scimus

quia verum est

testimonium eius

explicit secundum

iohannem

Sancti iohannis

apostoli et

evangelista

post epiphania

dominica prima

post ephipania dominica

secunda

Invelanda

In dedicatione sanctae mariae

Dominica ii xlgisima paschae

post octabas domini in ihu xpi

post iii dominicas de ephipania

de muliere samaritana

De xlgisima feria iiii

In sancti angeli et in dedicatione

fontas

Coutichiana

In natale sancti andreae

Coutichiana

post iiii dominicas xlgisima

feria iiii

post iiii dominica xlgisima feria

·iiii·

The most likely source for such a manuscript in seventh-century Northumbria is undoubtedly Wearmouth–Jarrow. The early Church in England did, however, have a long and consistent connection with Italy and the Mediterranean. The first missionaries to the Anglo-Saxons, Saint Augustine of Canterbury and his followers, came direct from Rome on the orders of Pope Gregory the Great. They brought books with them, and further books were subsequently dispatched from Rome with those who, like Saint Paulinus, were sent in later years to reinforce the mission. Books reputed to have belonged to Saint Augustine were preserved as relics at Canterbury in the later Middle Ages, and what is almost certainly one of these, an illuminated copy of the Four Gospels, is still in existence (Corpus Christi College, Cambridge, MS 286). It dates from the sixth century and was written and decorated in Italy. One of Saint Augustine's successors as archbishop of Canterbury was Theodore of Tarsus, who had been a monk in Rome before coming to England in 669. He was accompanied by another monk, Hadrian, who had been born in Africa but whose original monastery was in Campania, not far from Naples. Hadrian was appointed abbot in Canterbury. Both these were learned men who attracted many students and who had doubtless brought further manuscripts with them to England.

In Northumbria during the first decades after the conversion, in-spite of the initial Roman impetus of Saint Paulinus, the closest external links were with Ireland through Iona. However, after the Synod of Whitby in 664 had settled the disagreement over the calculation of the date of Easter in favour of Roman rather than of Irish custom, with the result that many Celtic diehards withdrew from Northumbrian communities, direct links between Northumbria and Italy grew stronger. One personality whose activities had considerable influence was Saint Wilfrid of York (634-709), who had already made one journey to Rome before appearing at Whitby to represent the Roman case. He was to go there twice more in the course of his long and turbulent episcopal career, and we know that he took a great interest in books and in learning.

Most significant of all in this context are the careers of Benedict Biscop, who founded the monastery of Saint Peter at Wearmouth in 674, and of his friend and successor Ceolfrith, to whom he entrusted the establishment of the sister house of Saint Paul at Jarrow in 681. It was at Jarrow that the Venerable Bede spent almost the whole of his life. Benedict Biscop, who came of a noble Northumbrian family, had already been more than once to Rome before he settled at Wearmouth. He made two further visits, one of them in Ceolfrith's company, in order to bring back books, relics and works of art for his twin foundations. Unfortunately, none of his acquisitions have sur-vived, but we know that the books which he collected included fine texts written in Italy in the sixth century, outstanding amongst which were the Codex Grandior, a vast copy of the whole of the Bible, and some or all of the Novem Codices, a Bible in nine volumes, all of which had been made at Cassiodorus's monastery of Vivarium in the extreme south of Italy. The work of the scriptorium at Wearmouth–Jarrow was very much influenced by the script and appearance of these manu-scripts, which were emulated there with great success.

Contact between Lindisfarne and Wearmouth–Jarrow, only 40 miles apart, seems to have been close during the late seventh and early eighth centuries. As we have already seen, Eadfrith, creator of the Lindisfarne Gospels itself, asked Bede to compose a Life of his own monastery's special saint, Cuthbert. The names of both Benedict